I L♥ve My Hair

Coloringbook

By Chavonna Adams

Copyright © 2019 Chavonna Adams, Created By Vonna LLC

No part of this book may be reproduced or transmitted in any form or by any means, electronic or mechanical, including photocopying and recording, or by any information storage or retrieval system, except as may be expressly permitted in writing by the publisher. This book is protected by the copyright laws of the United States of America. Contact author at createdbyvonna@gmail.com

Printed in the United States of America

This book is dedicated to my loving mother, Brenda.

"Polka Dots and Afro Puffs"

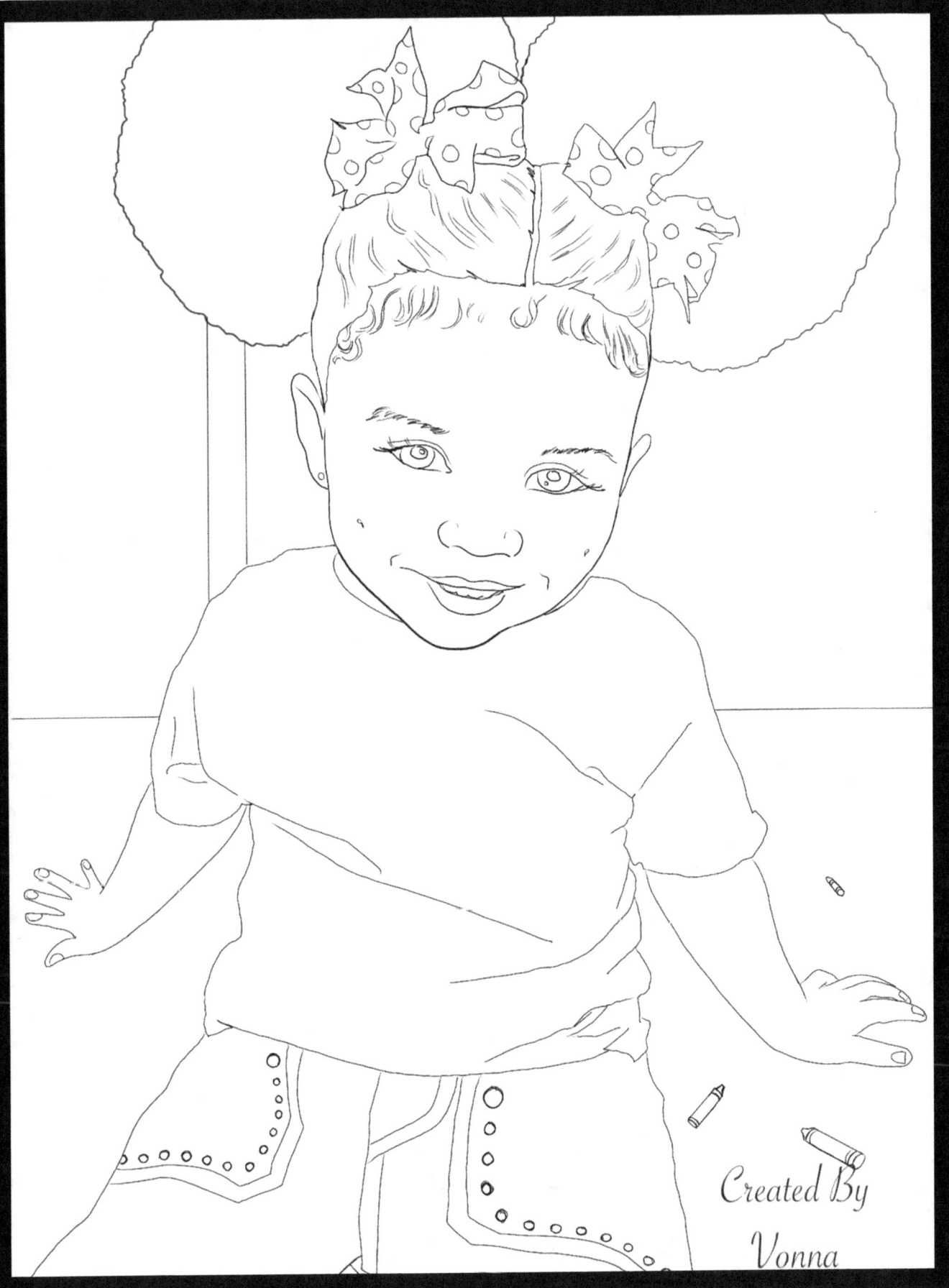

"Faded"

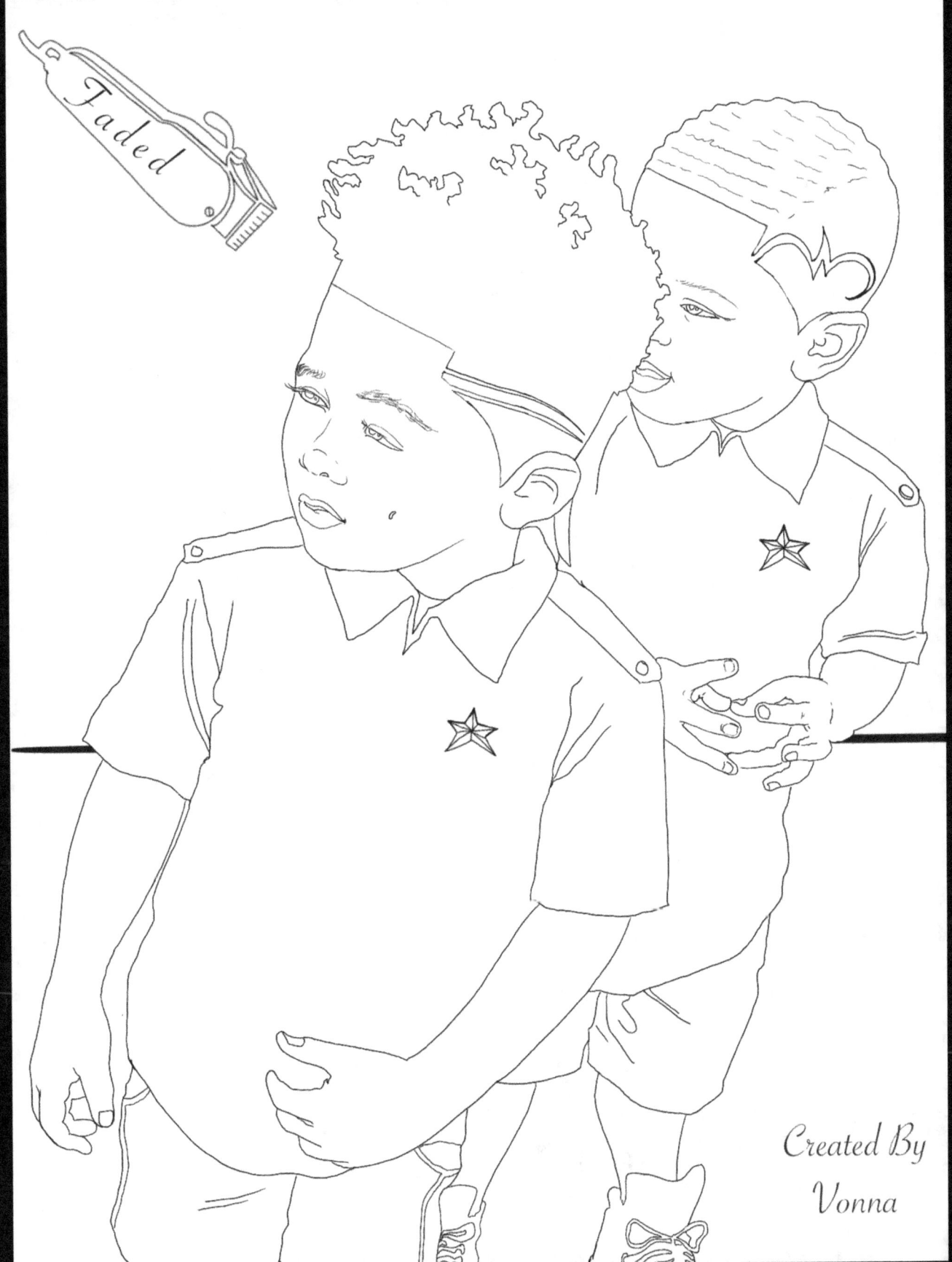

"Black Girls Rock"

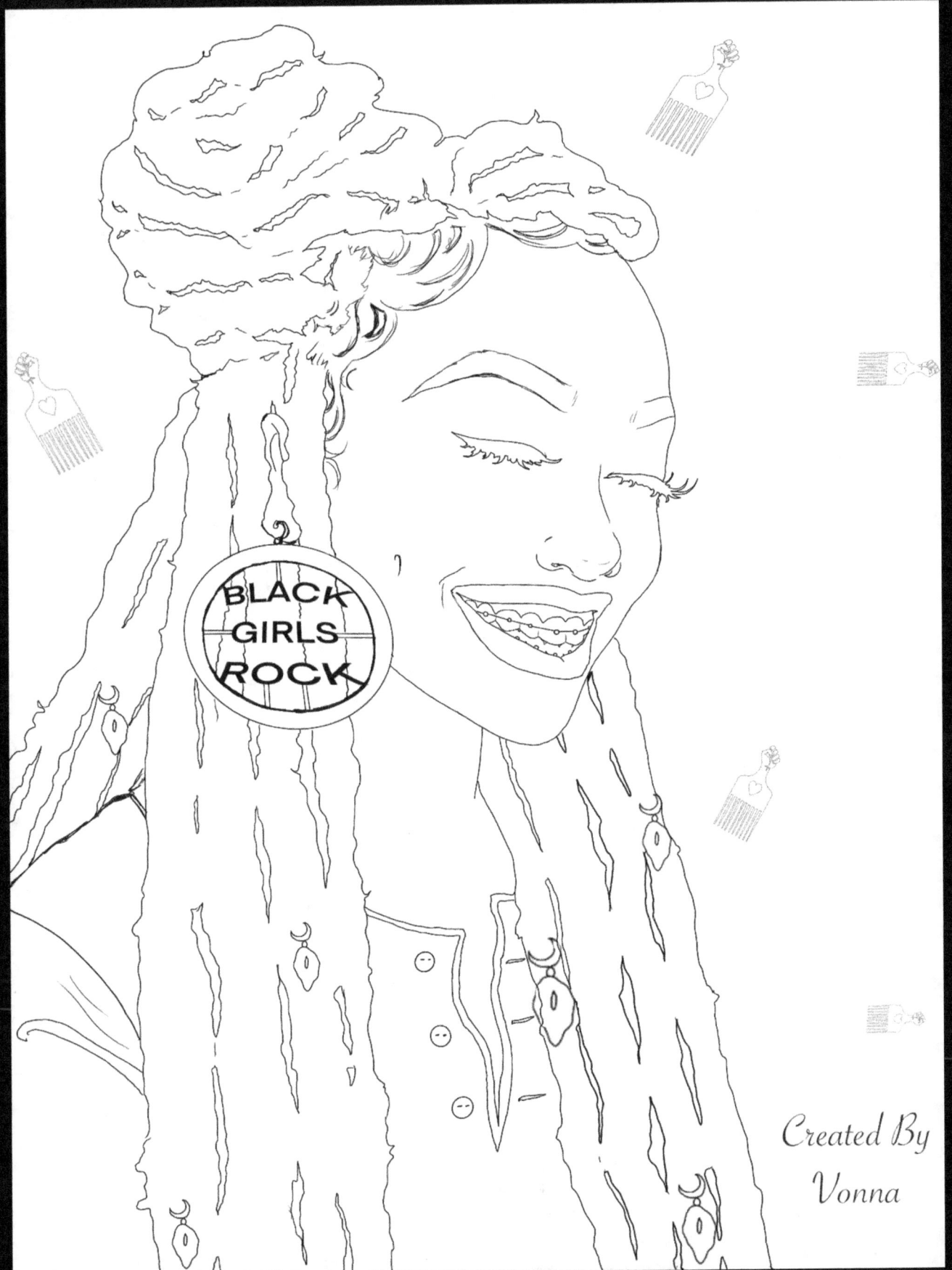

"Family"

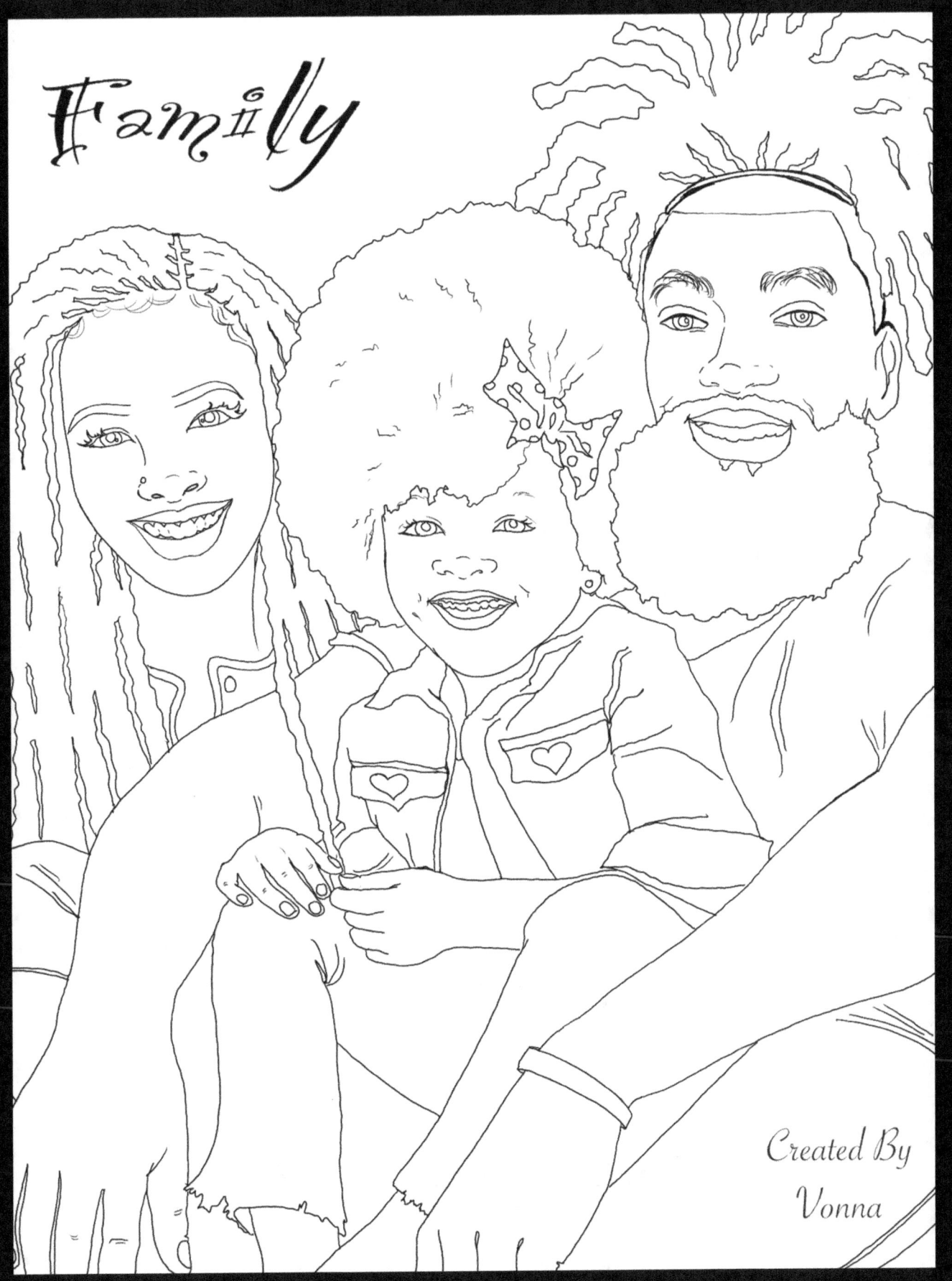

"Curls, Curls, Curls"

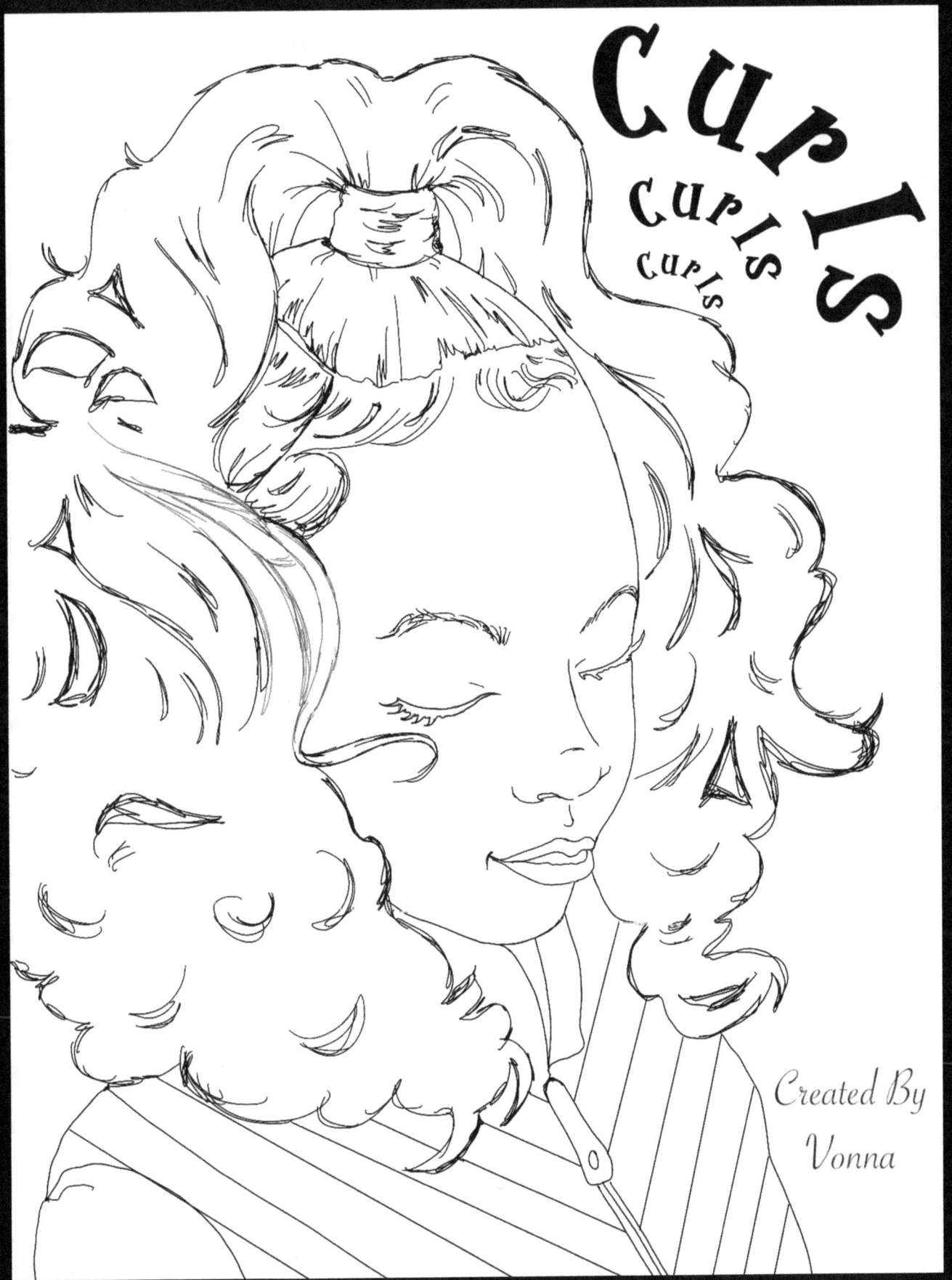

"Wavy"

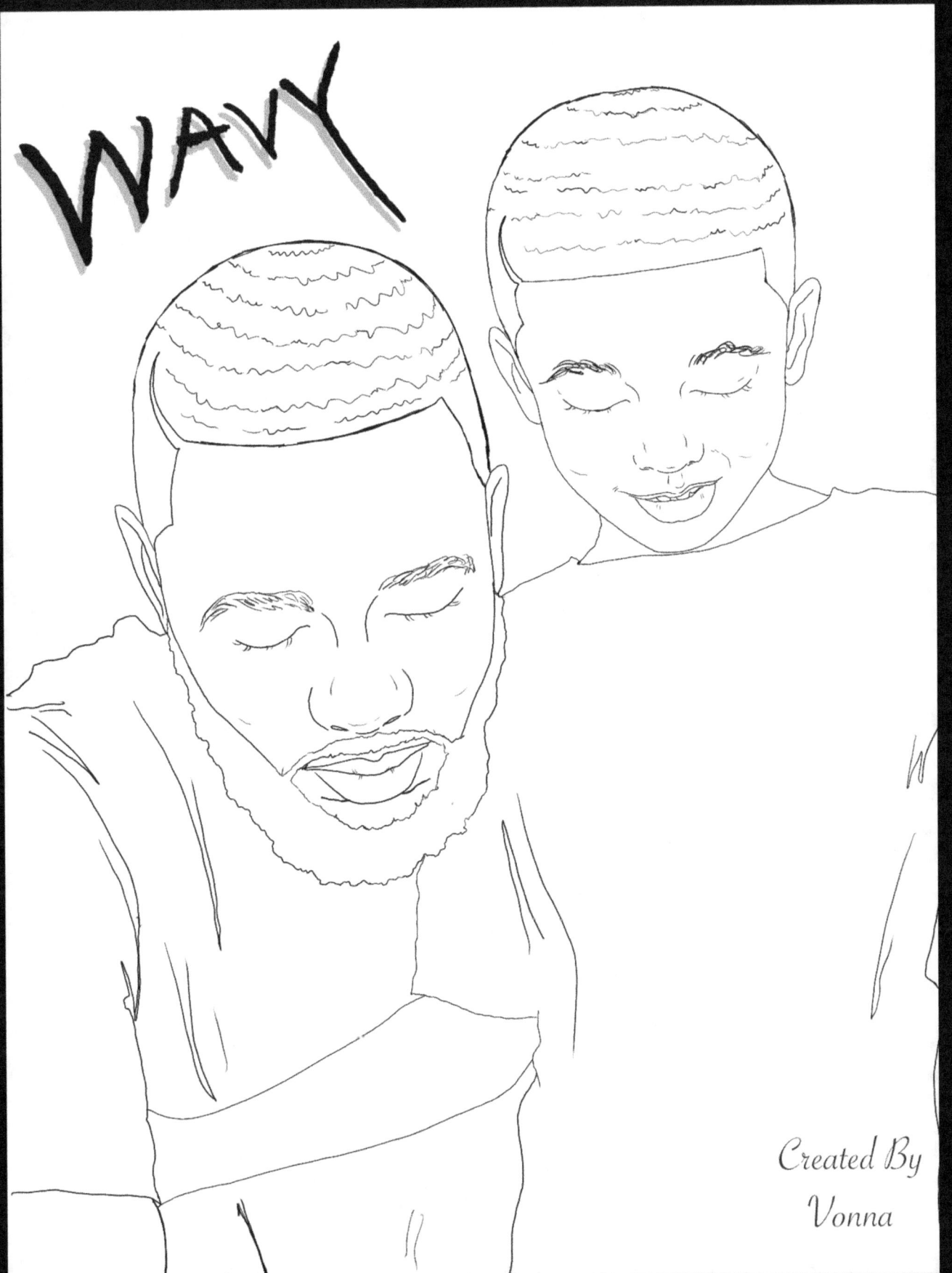

"Flower Girl"

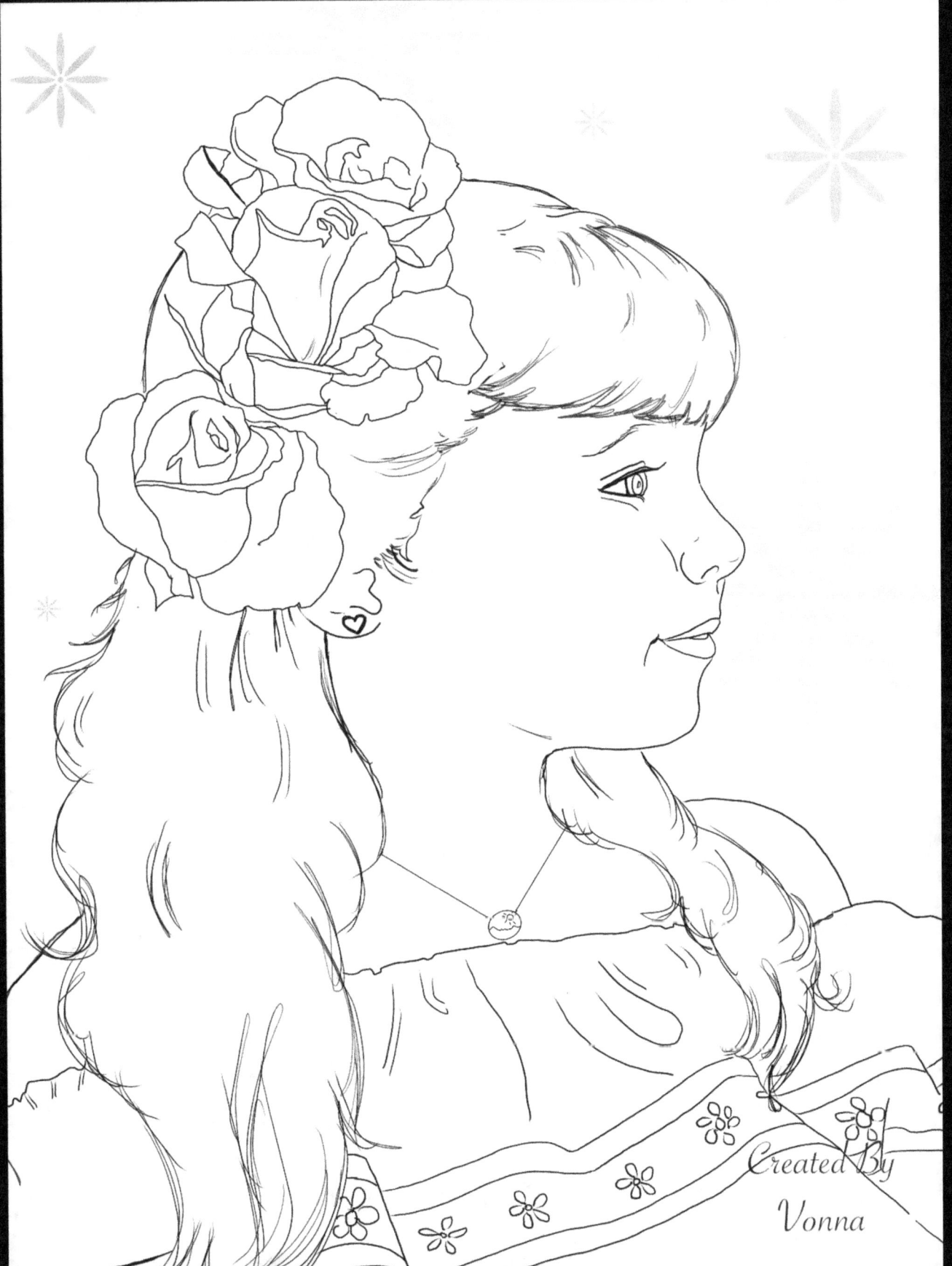

"Razor Sharp"

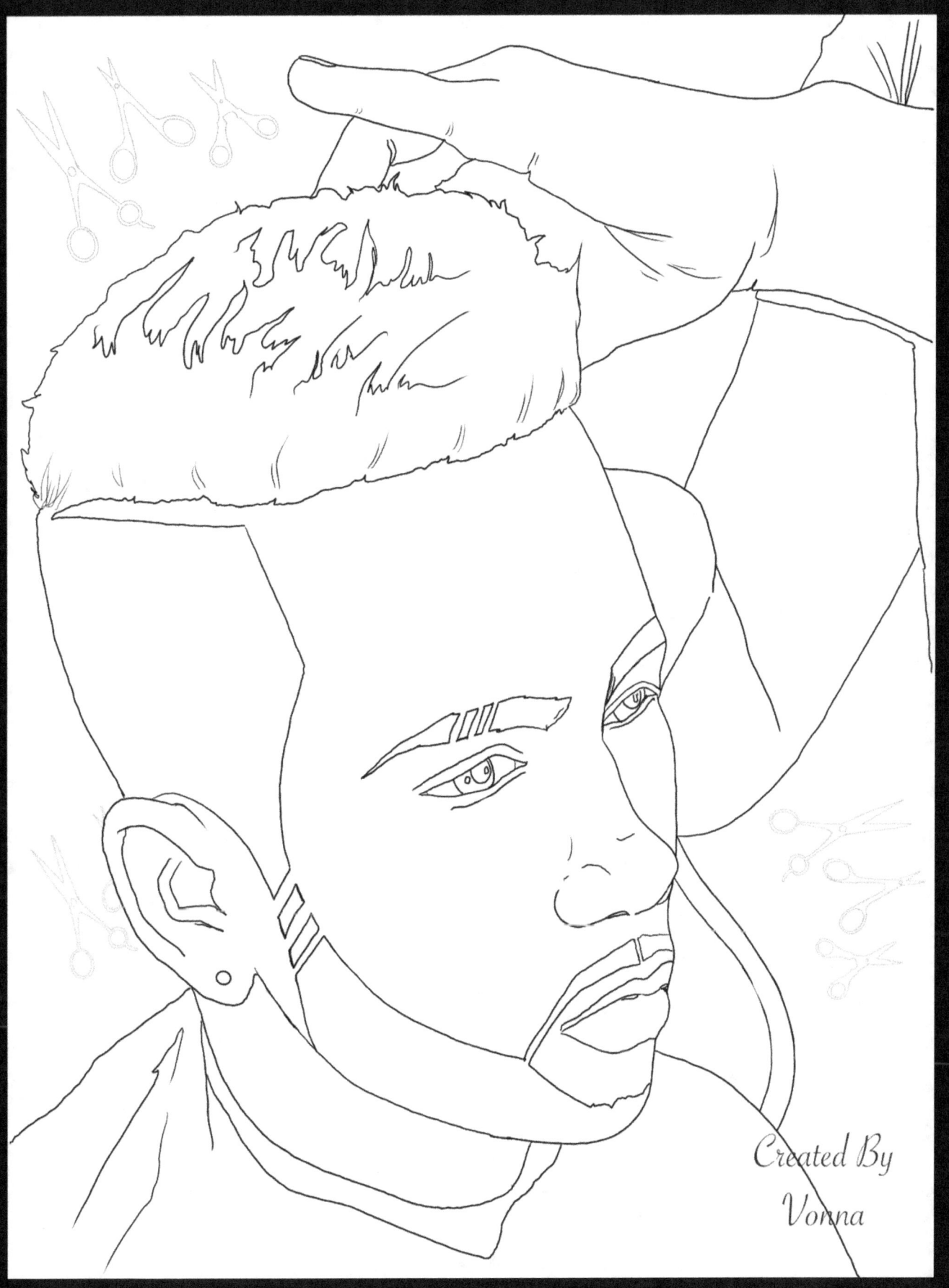

"Make Me Over"

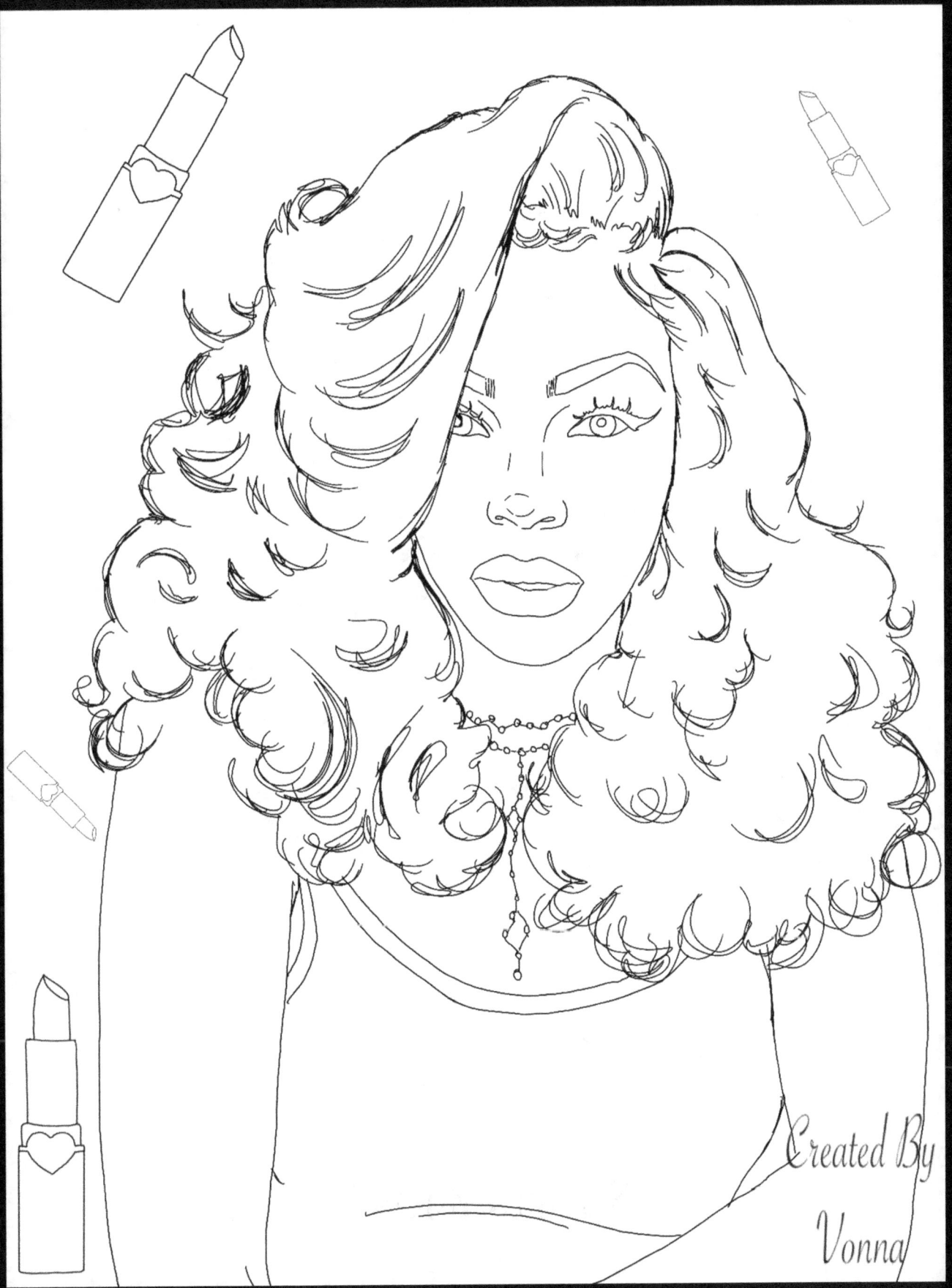

"Sports Kids"

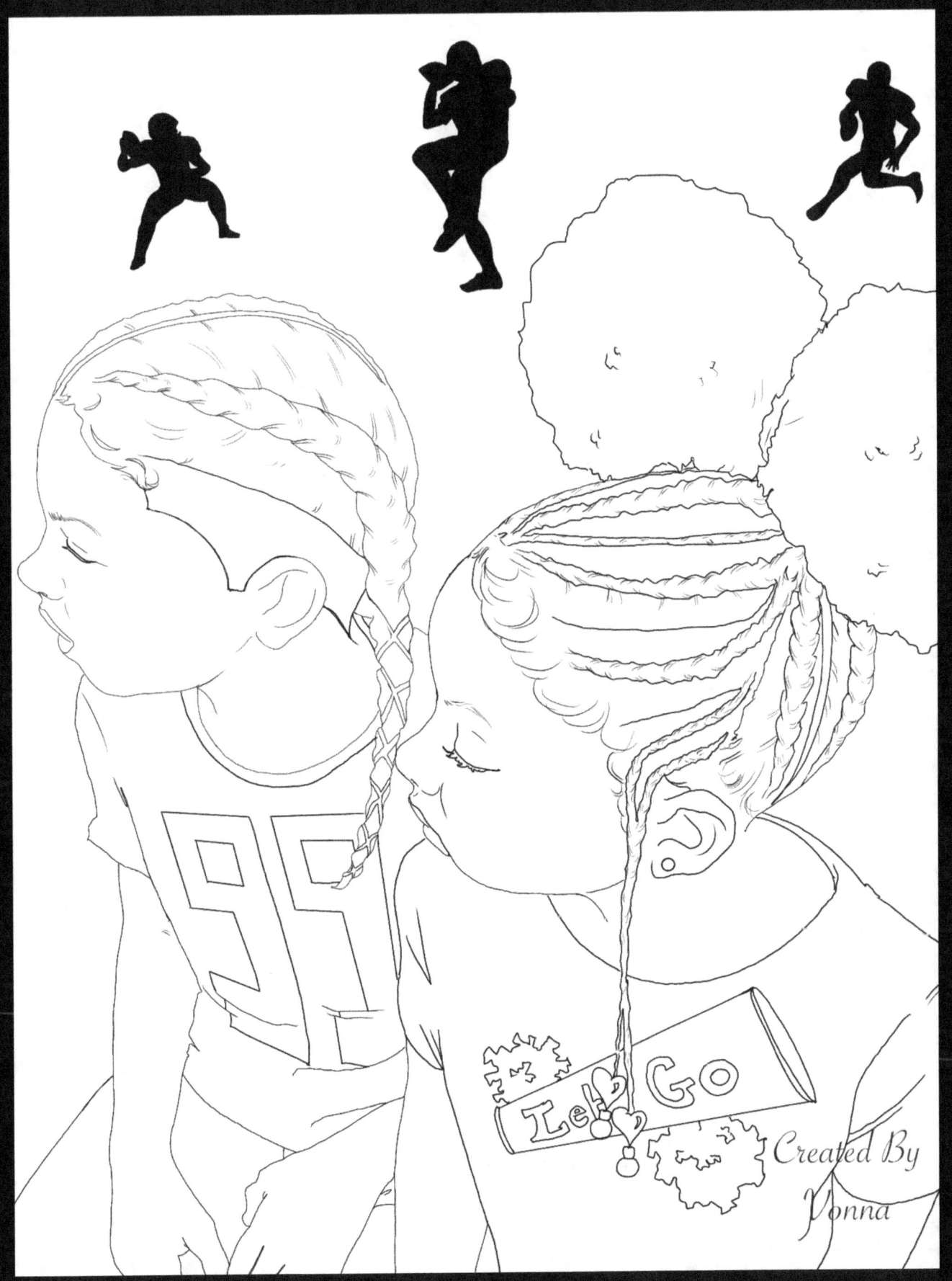

"School Girl"

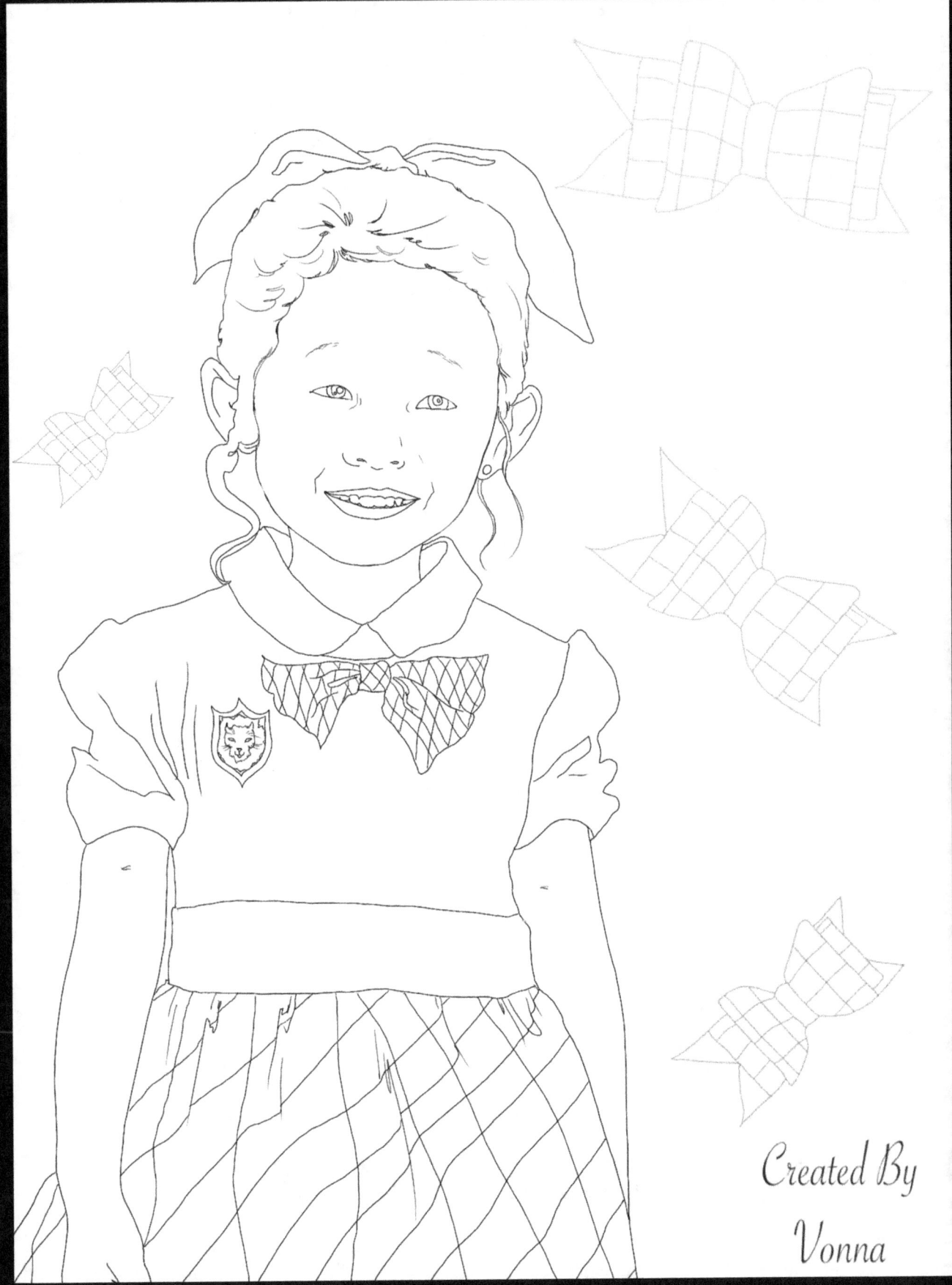

"I Love My Mom"

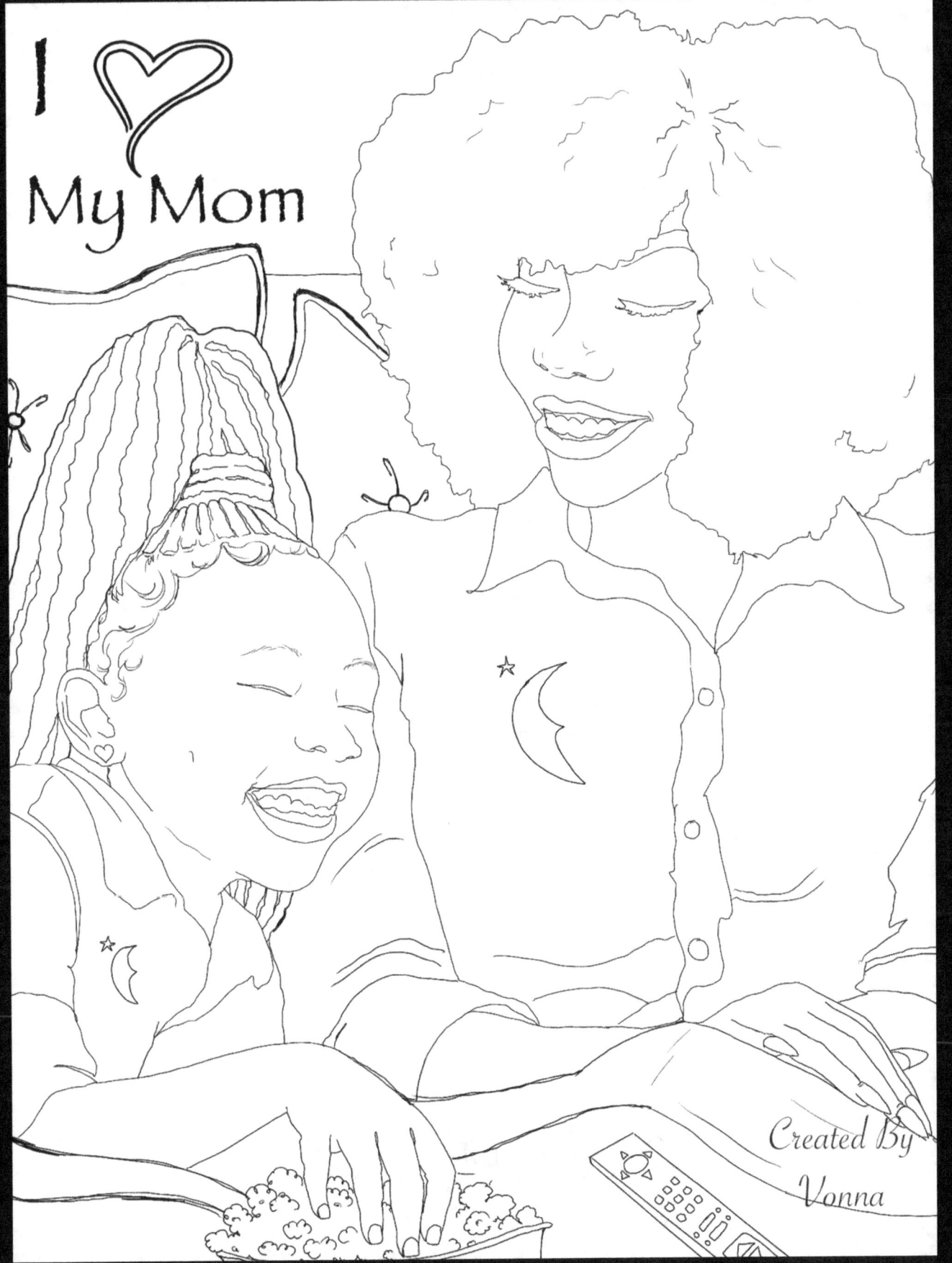

"I Love My Dad"

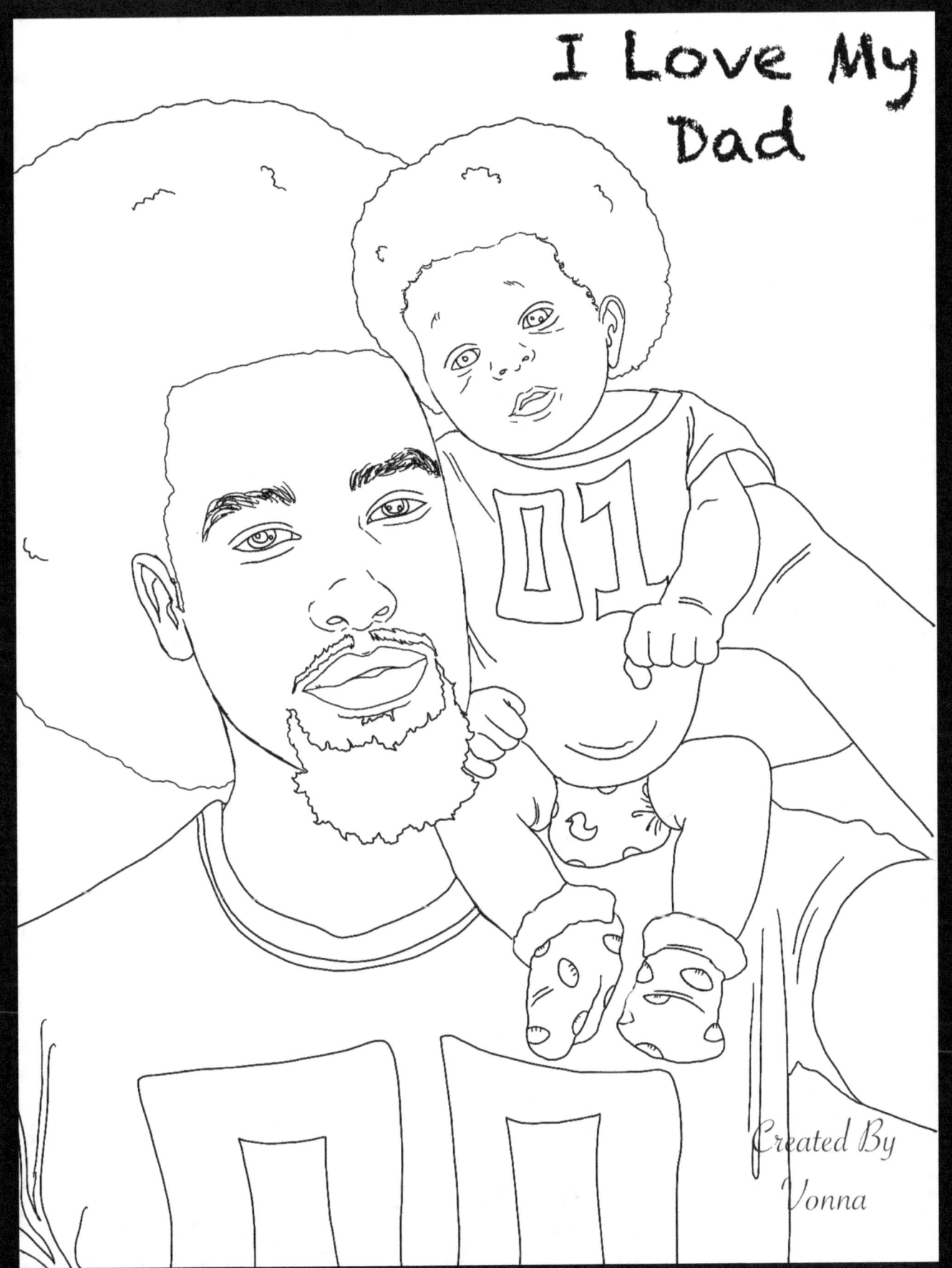

"Checkered"

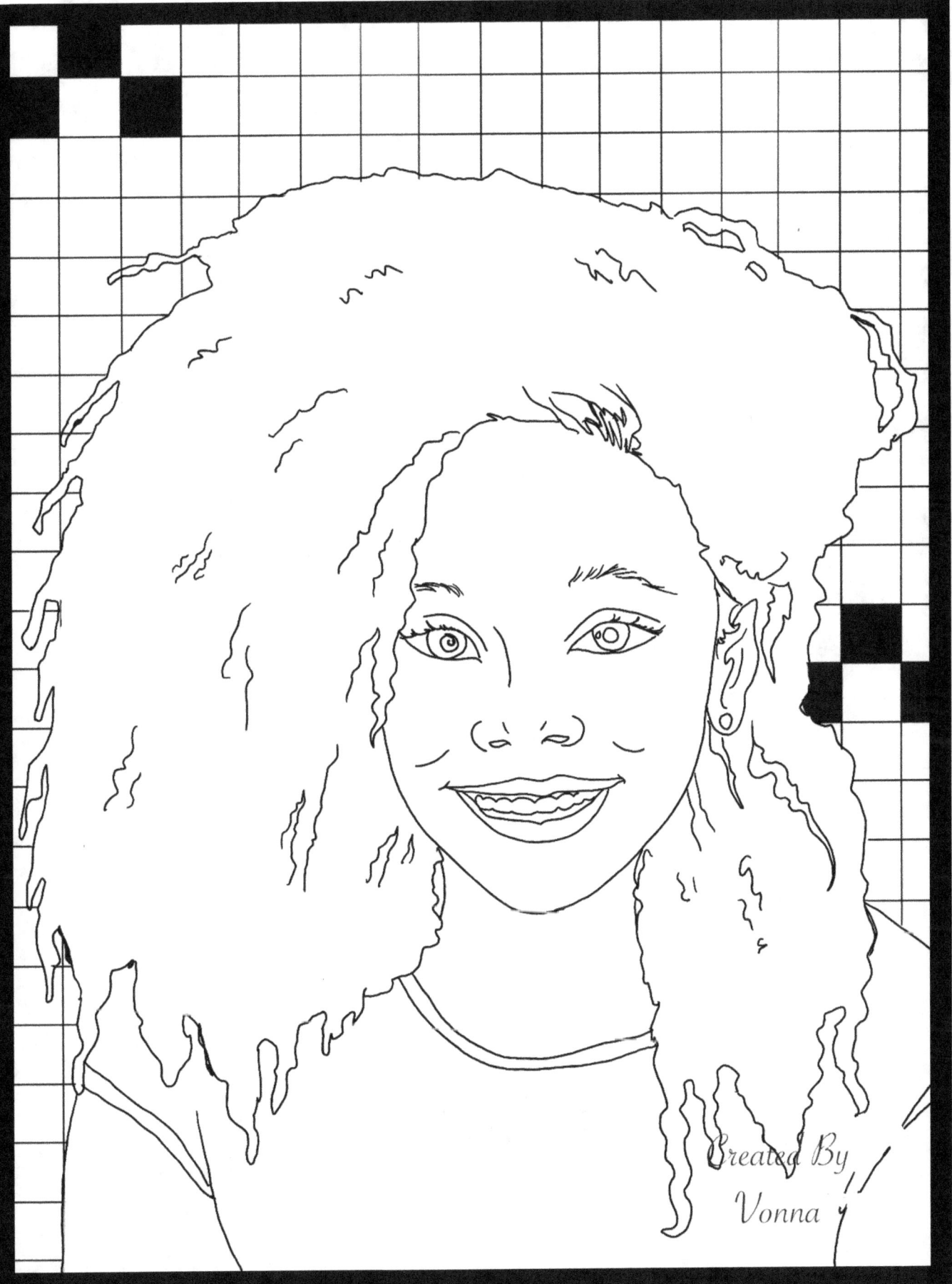

"Fresh Cutz"

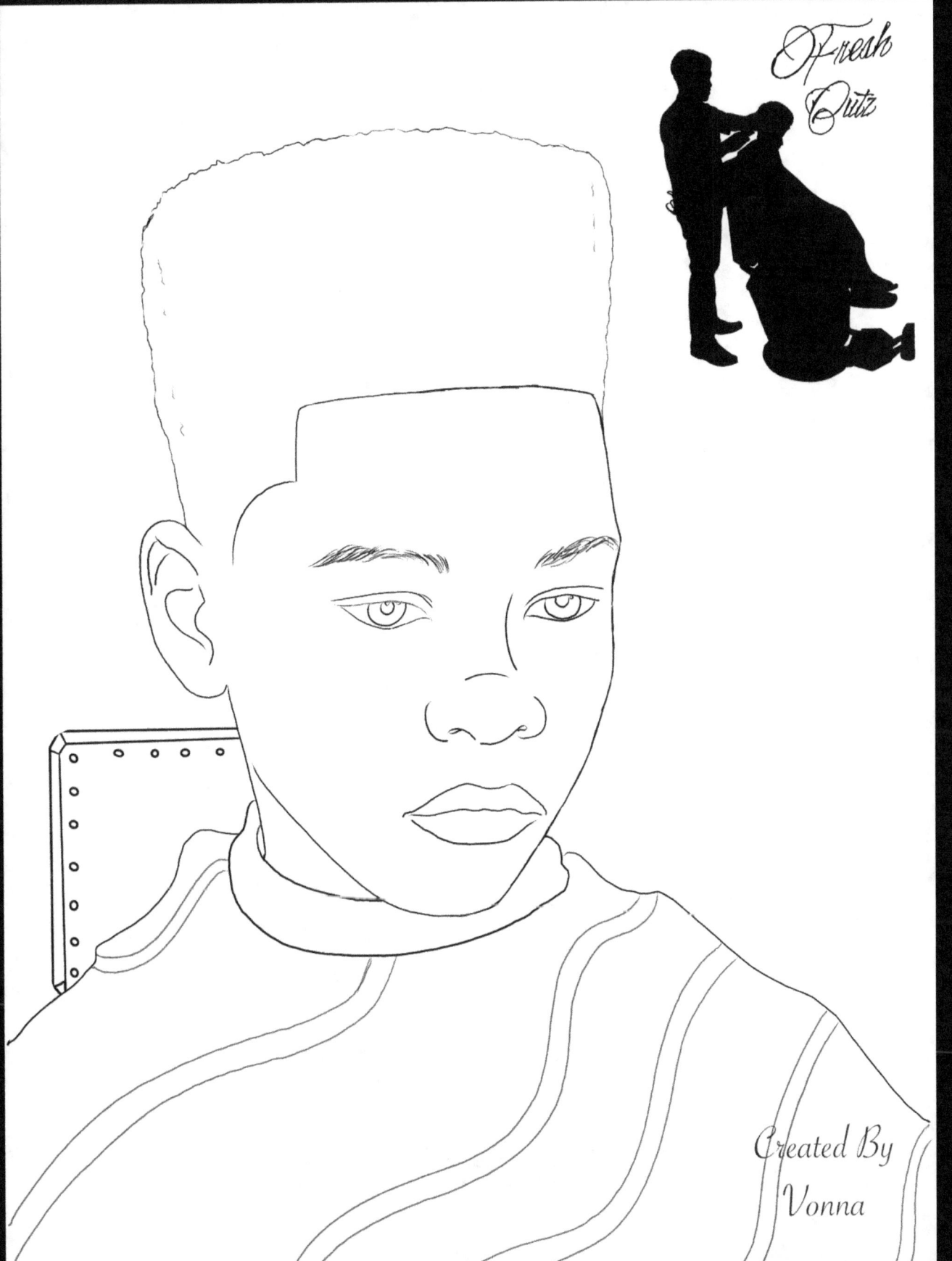

"Slayed"

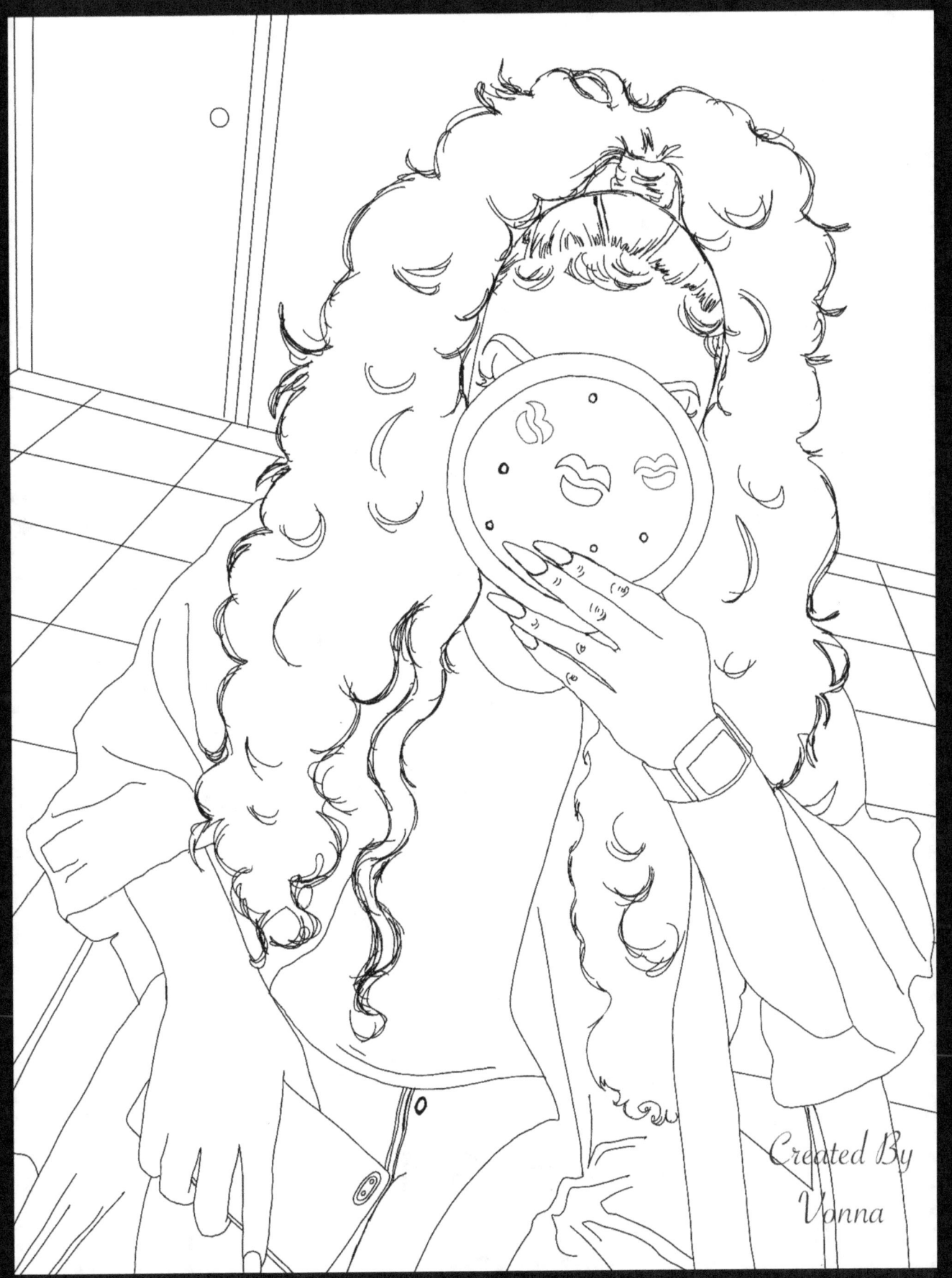

"Afro Girl"

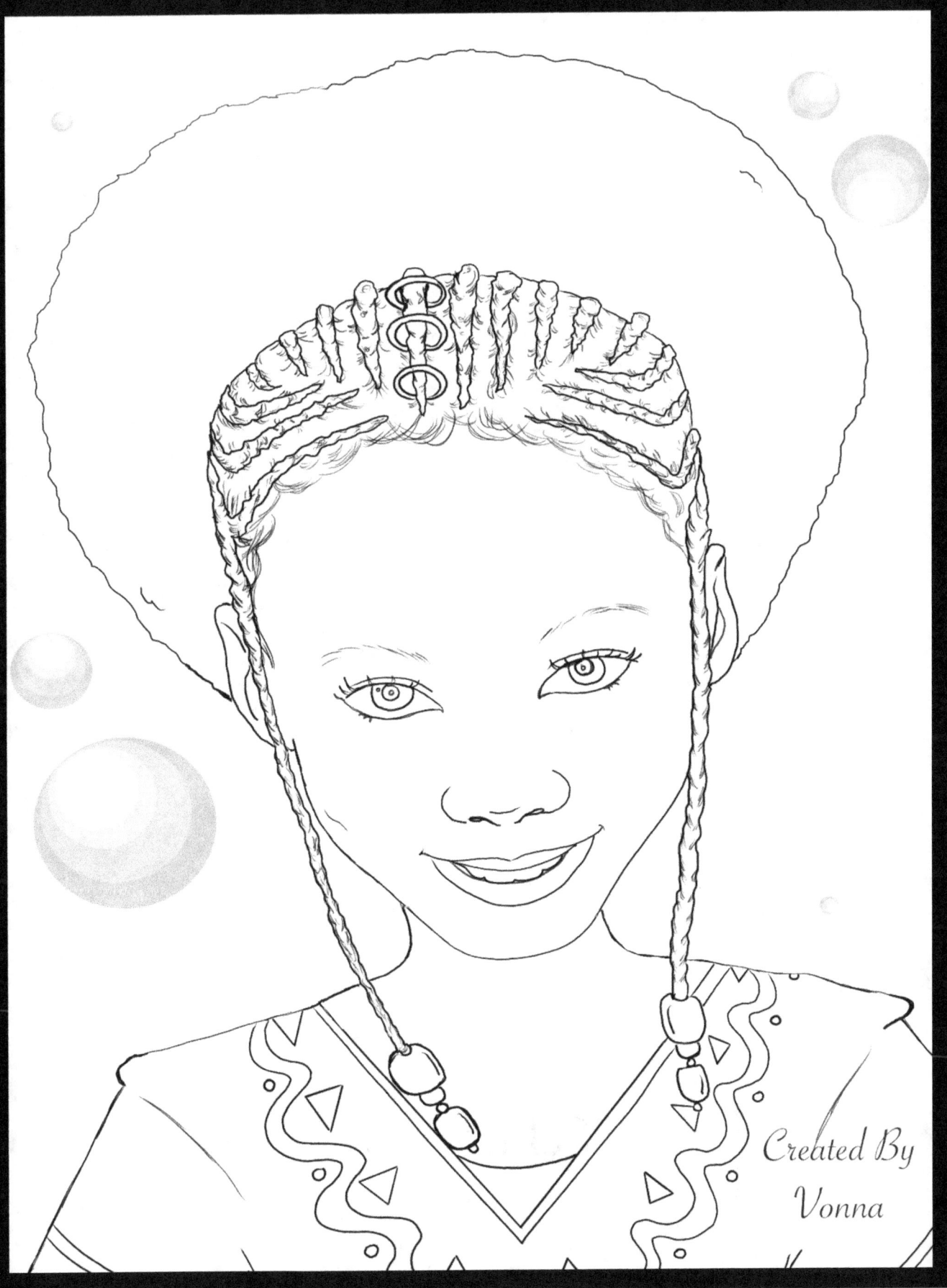

"School Boy"

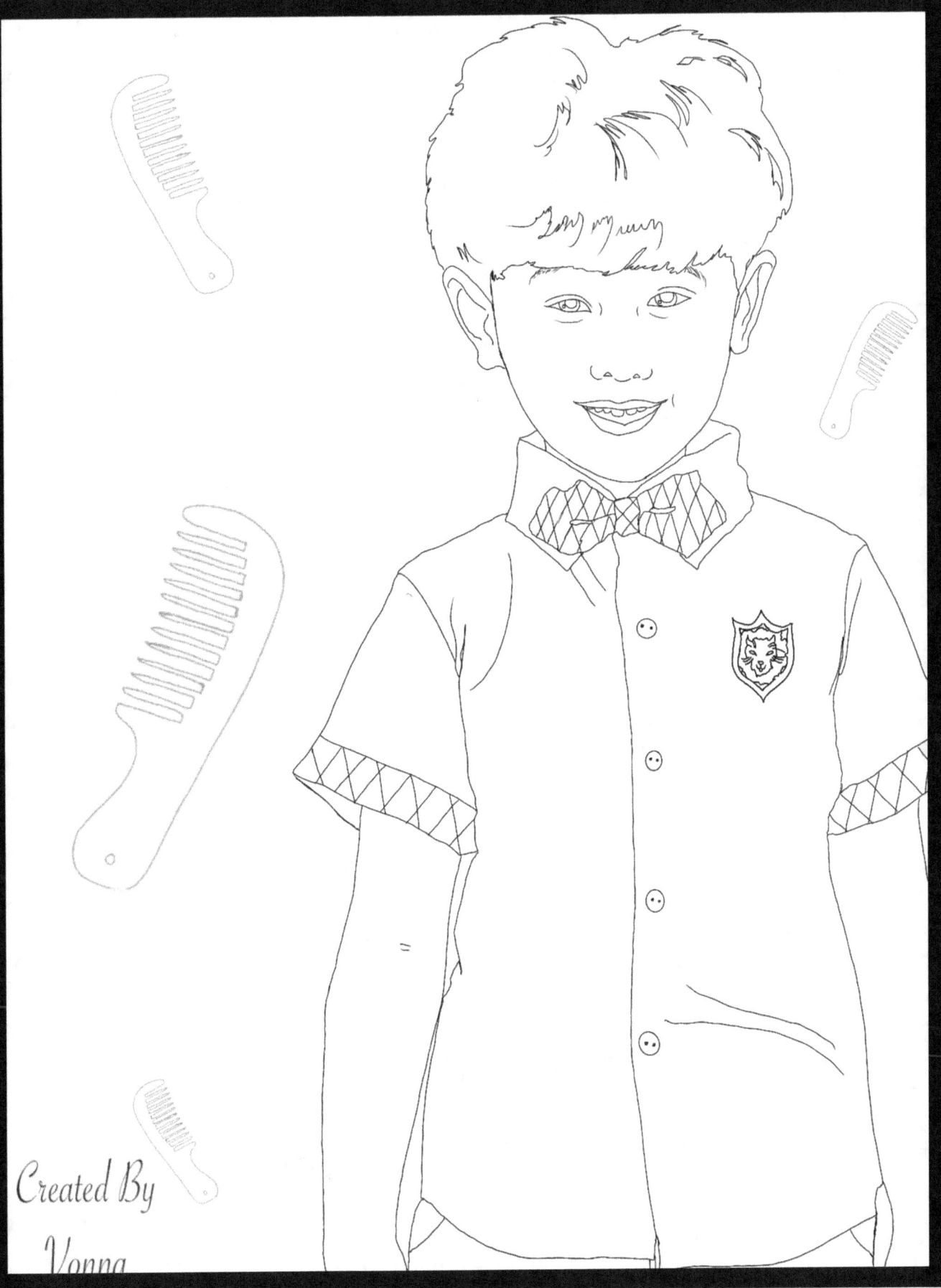

"Ponytails and Pins"

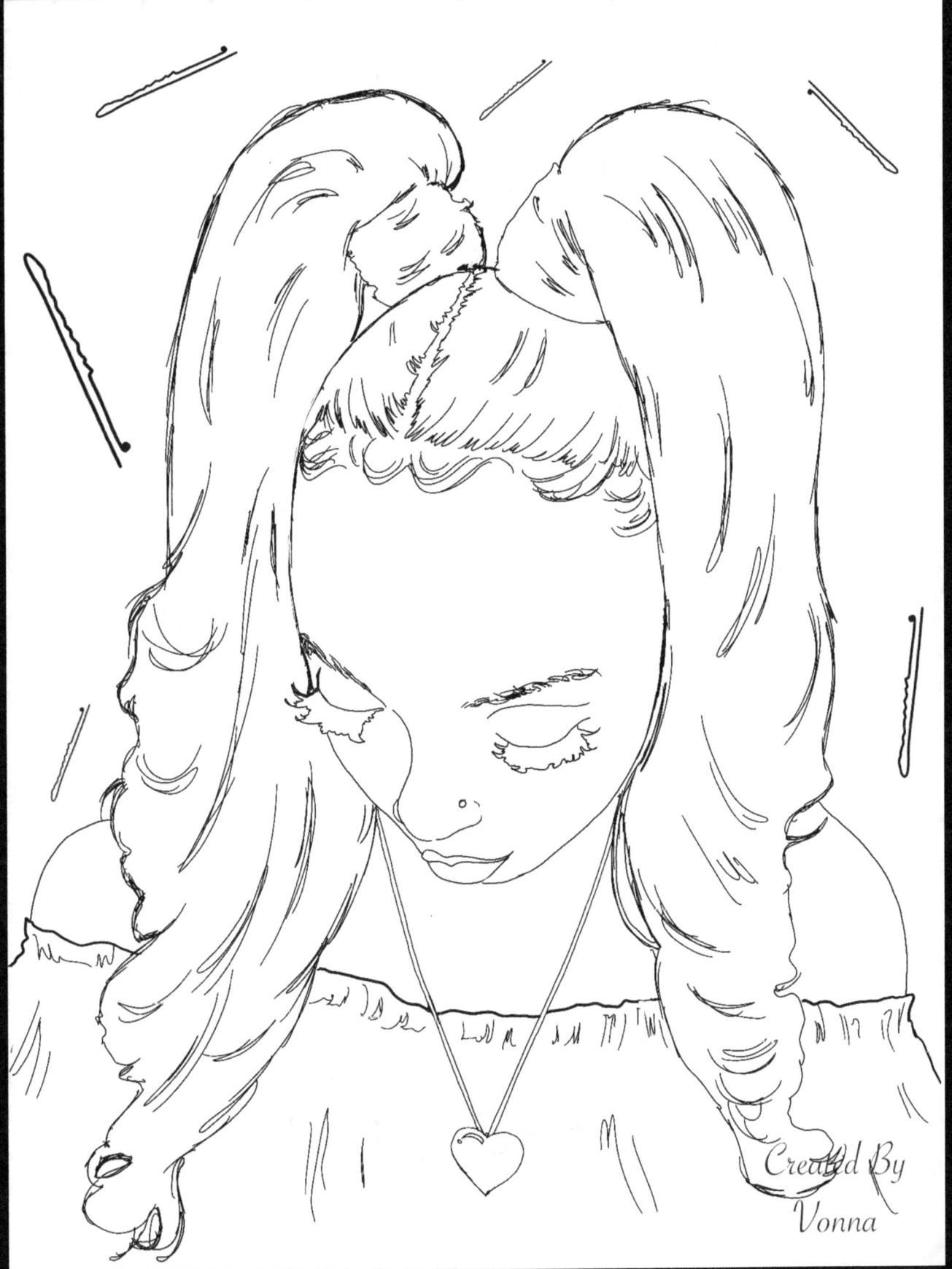

"Barbershop Boy"

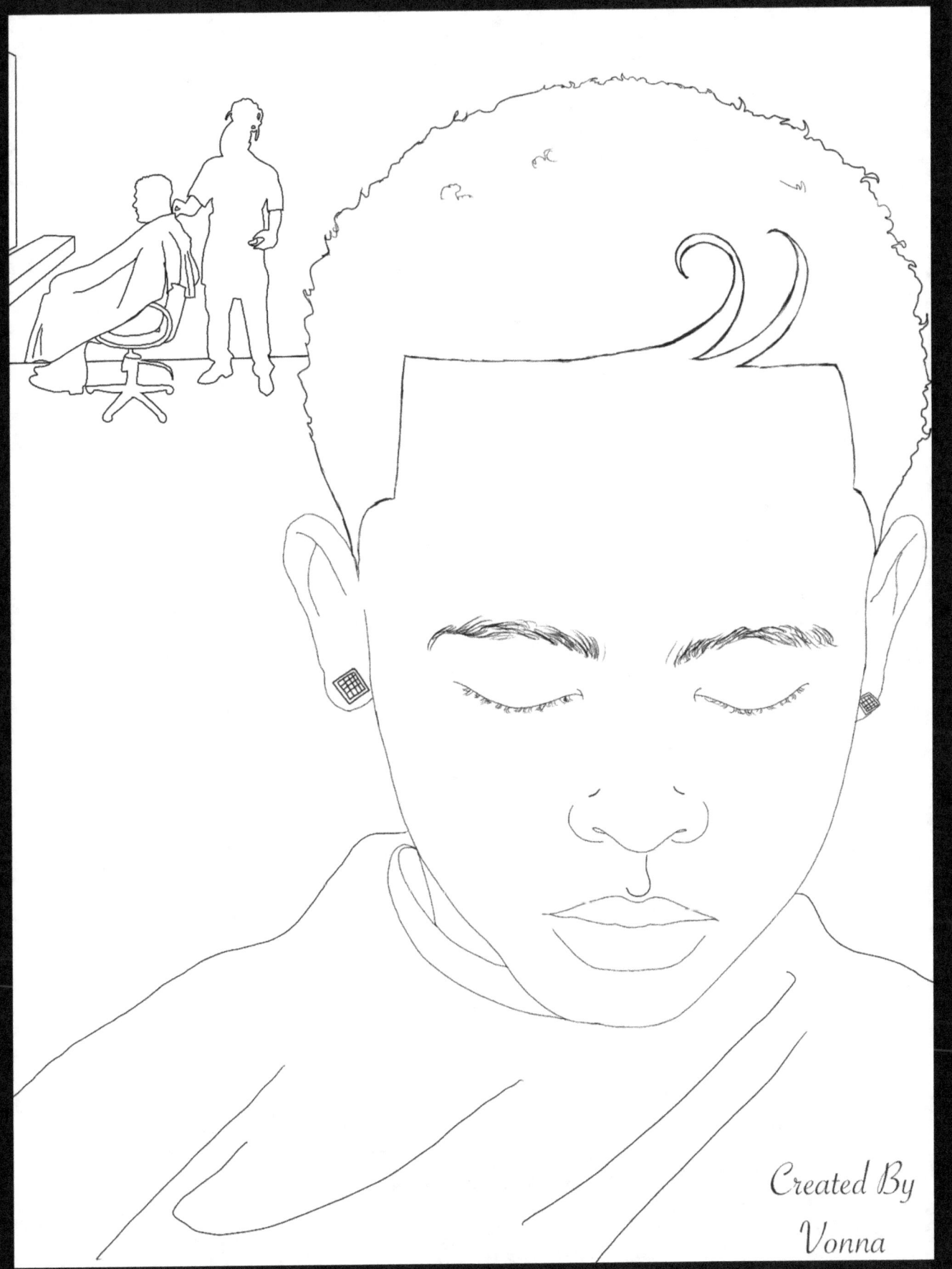

"Sisterhood"

Sisterhood

Created By Vonna

"Break' N"

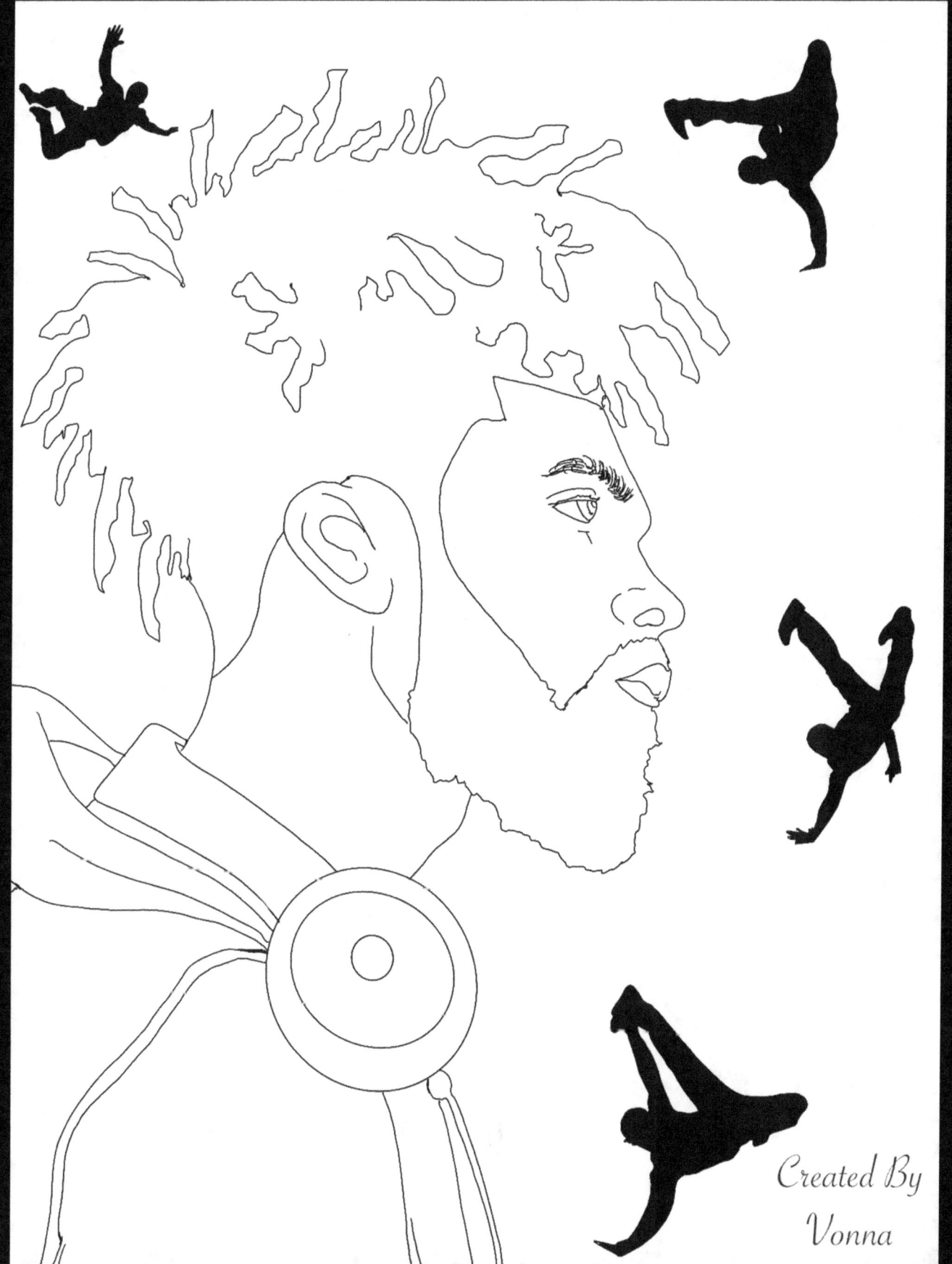

"Nailed It"

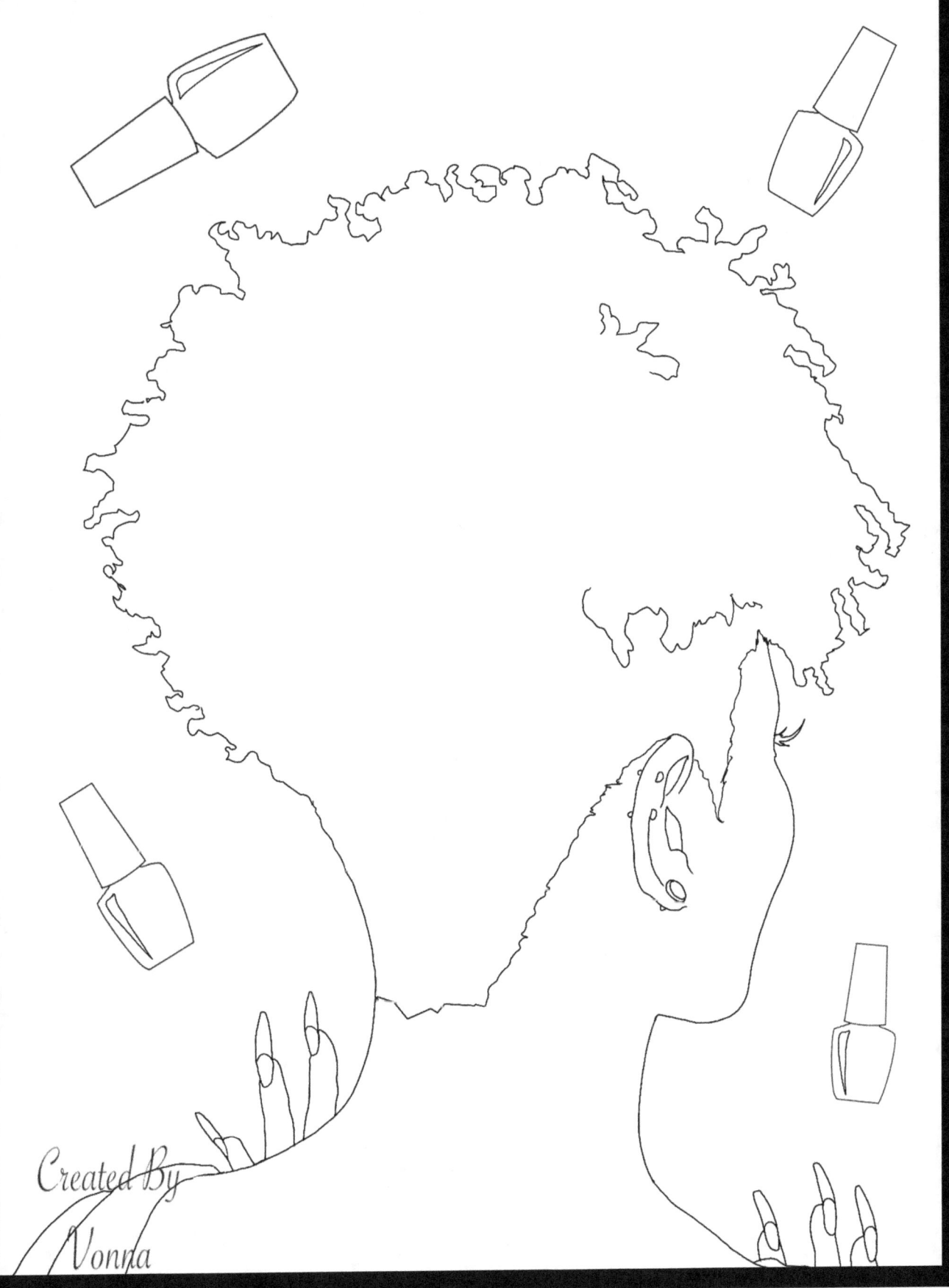

"Twisted"

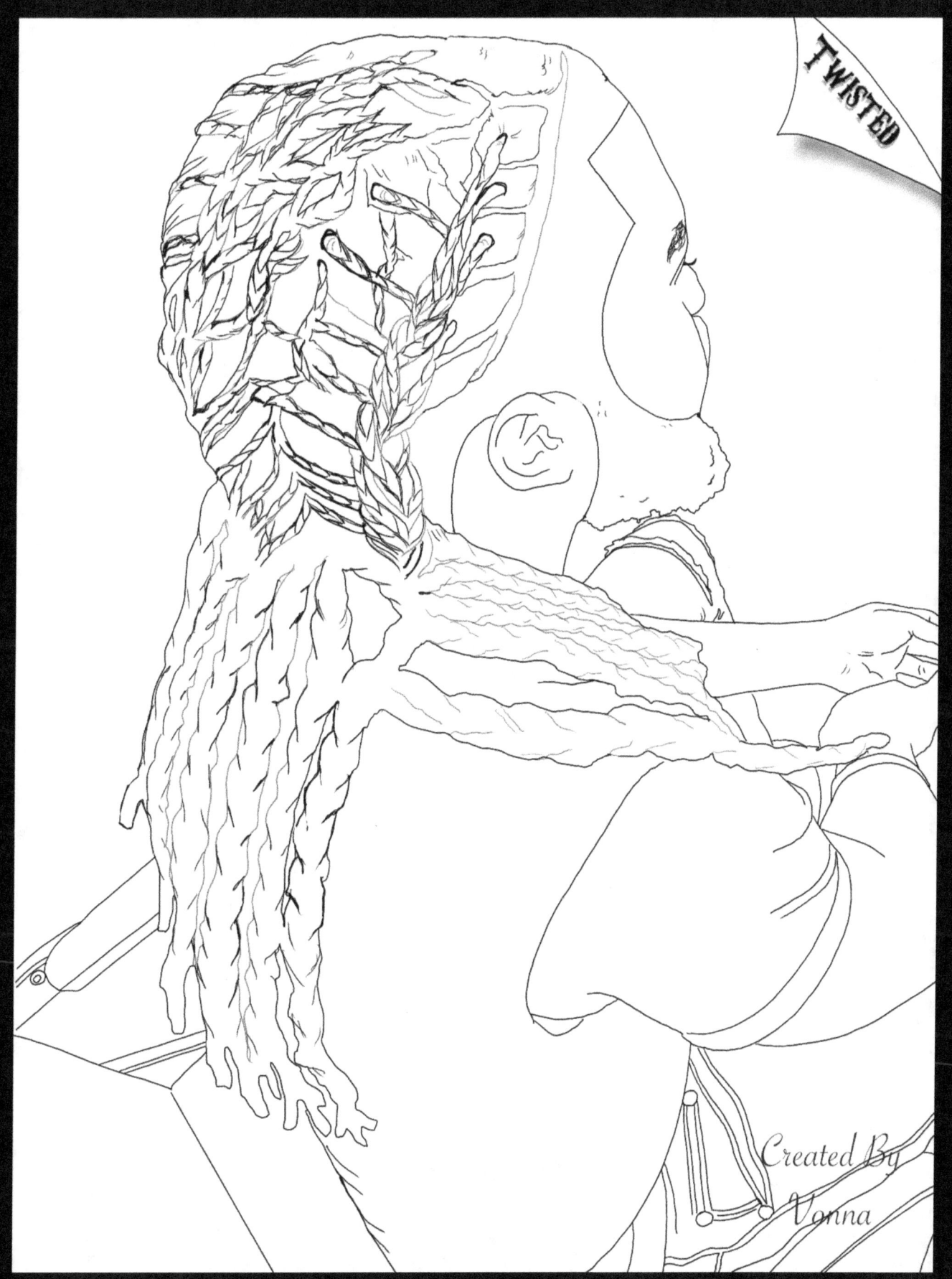

"Blow Out"

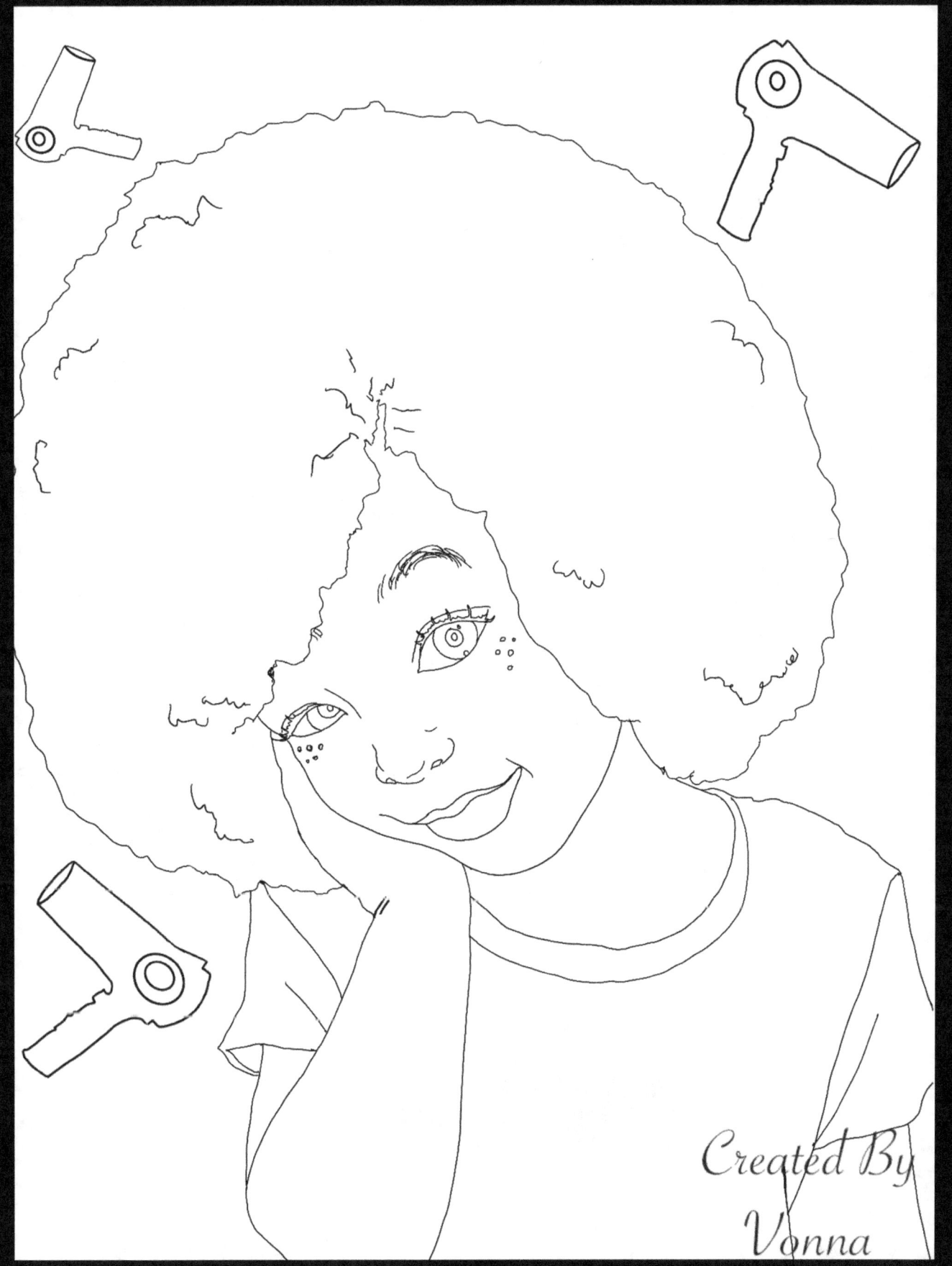

"Say It Loud"

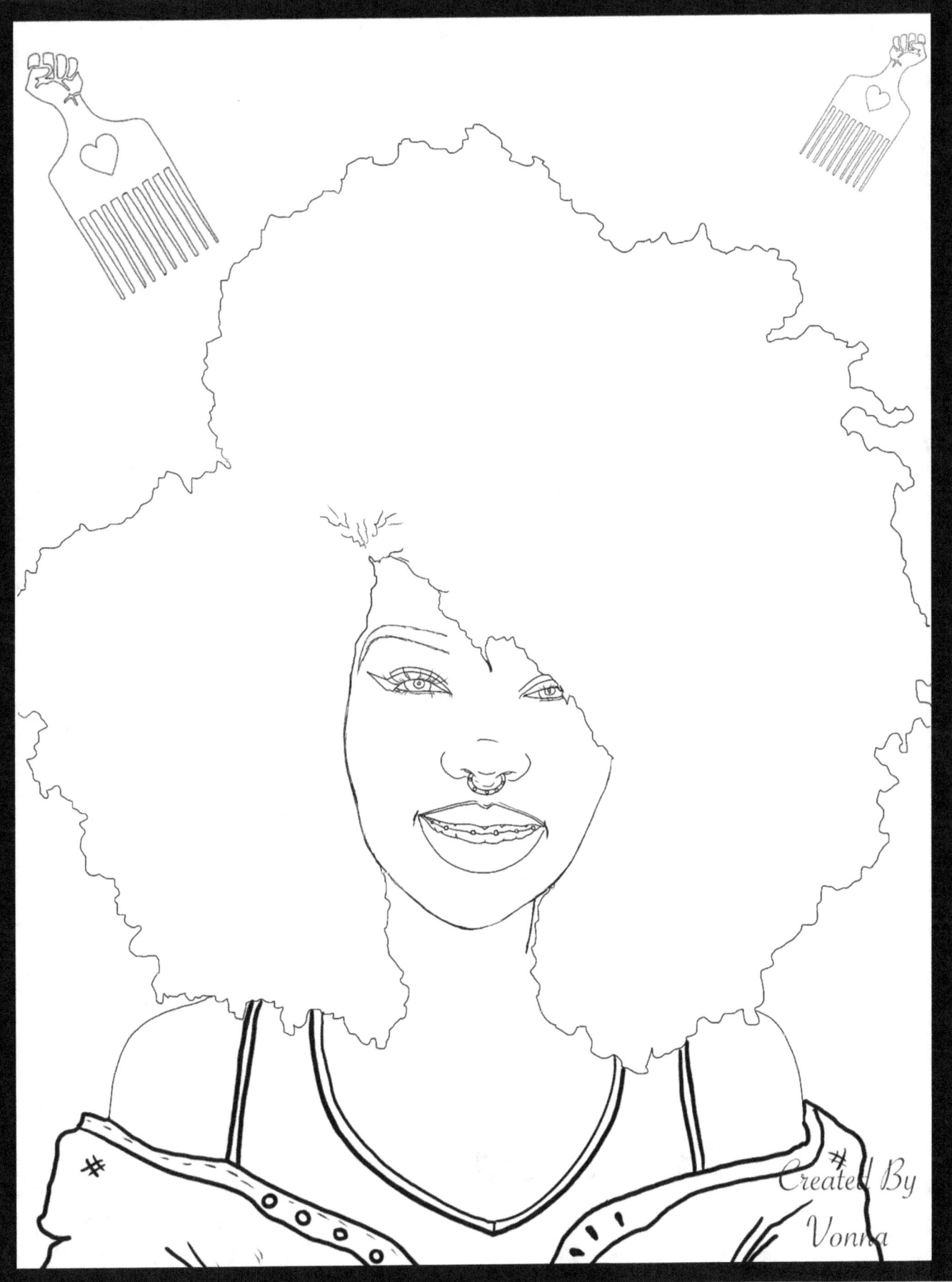

"Braids and Beads"

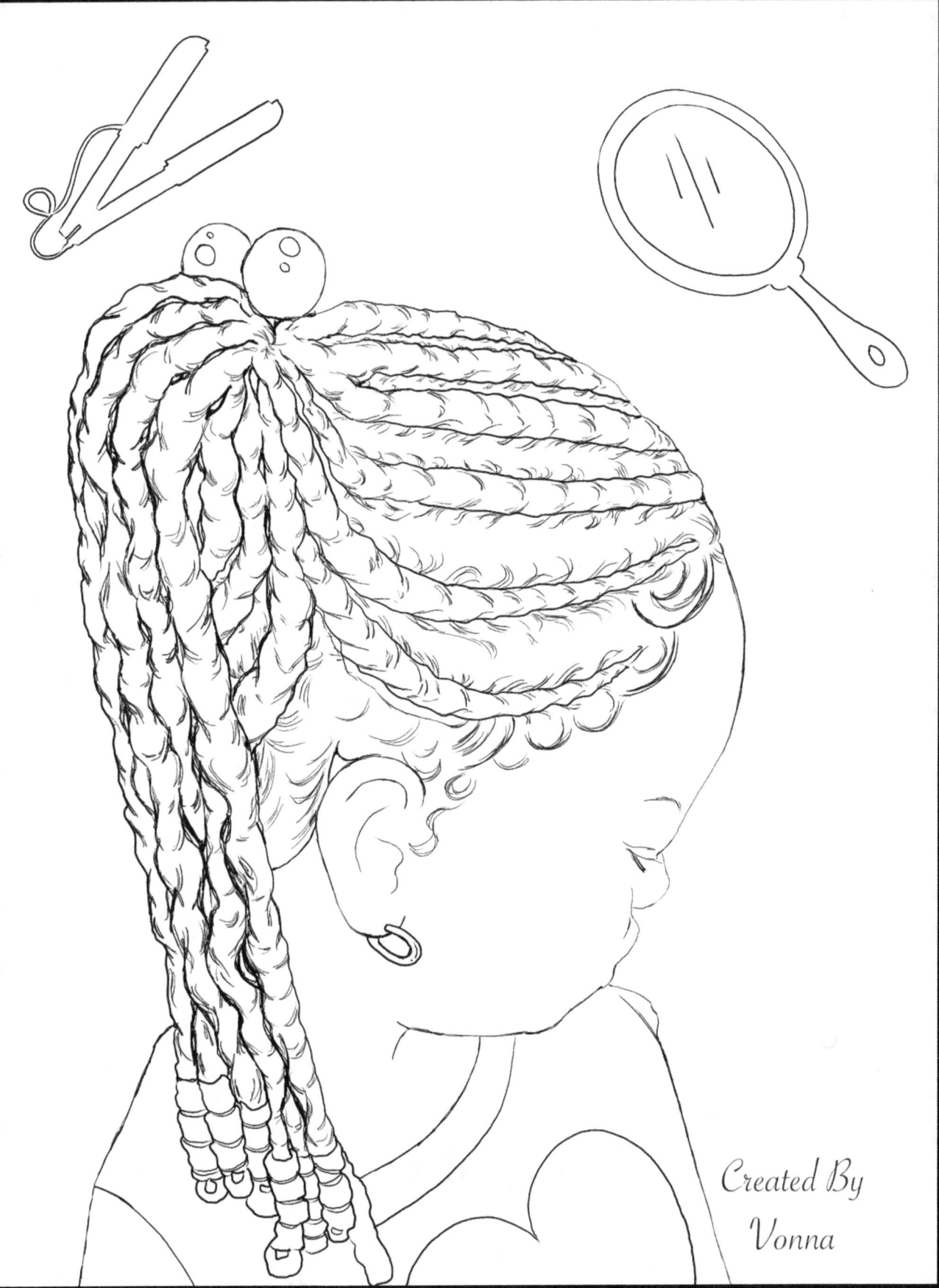

"Kinks"

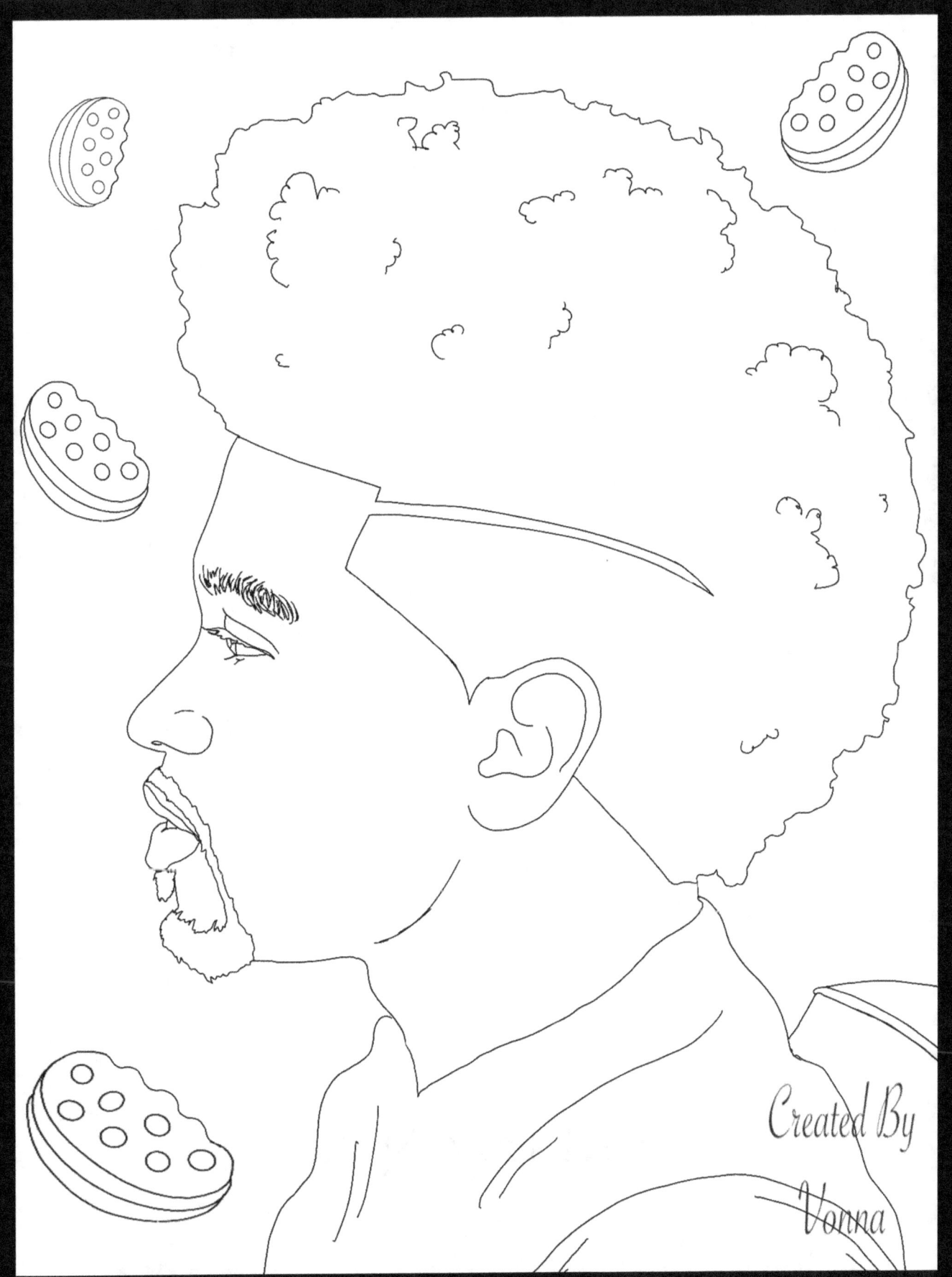

"Sparks and Spikes"

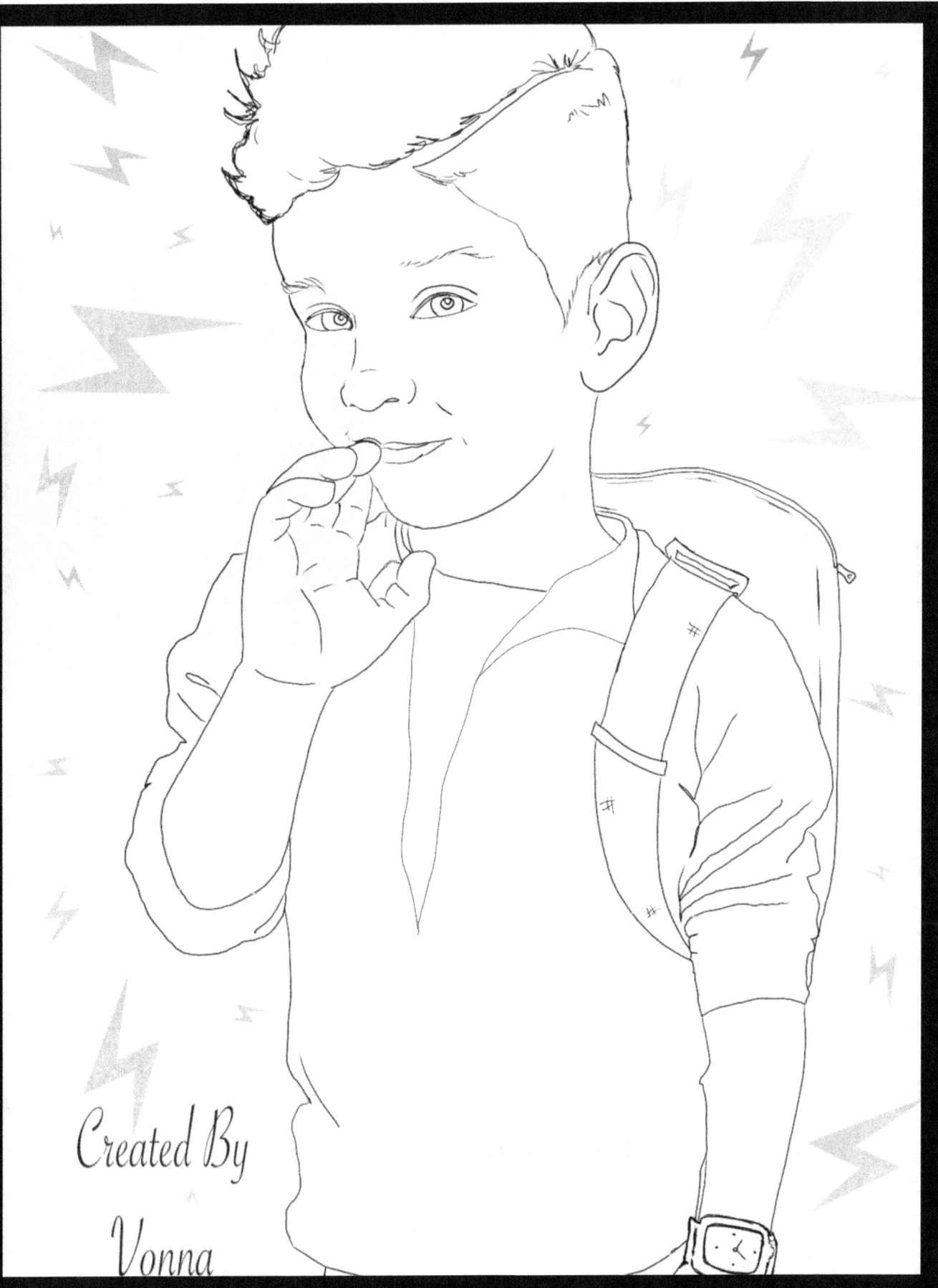

"Puffy Ponytails"

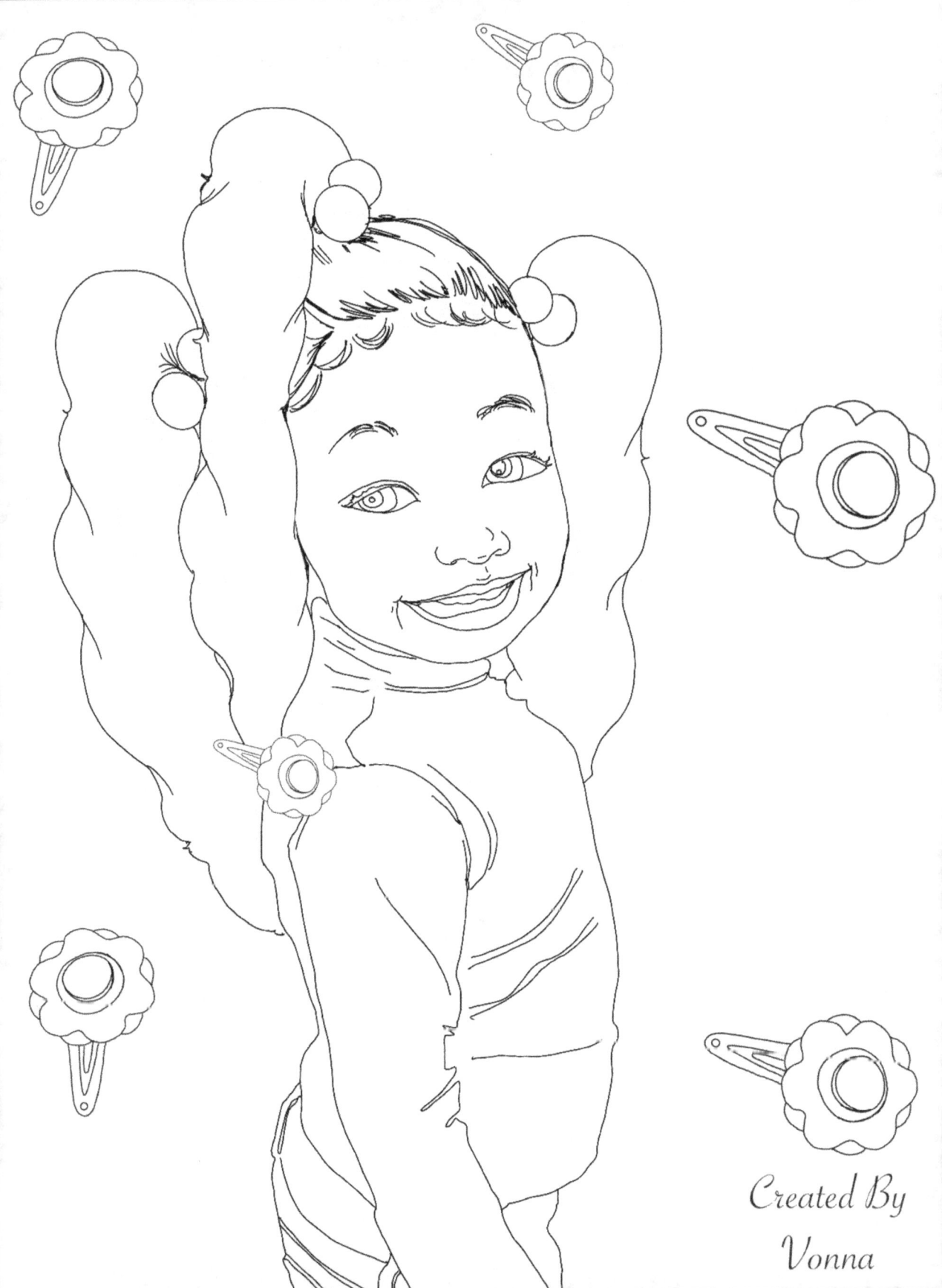

Create Your Own

www.ingramcontent.com/pod-product-compliance
Lightning Source LLC
Chambersburg PA
CBHW081459220526
45466CB00008B/2717